FLOWERS IN COLORED PENCIL

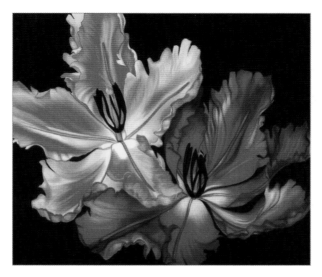

By Cynthia Knox

www.walterfoster.com

www.walterfoster.com
3 Wrigley, Suite A
Irvine, CA 92618

Author: Cynthia Knox
Project Manager: Sarah Womack
Associate Publisher: Elizabeth T. Gilbert
Art Director: Shelley Baugh
Production Artists: Debbie Aiken and Rae Siebels
Managing Editor & Licensing Coordinator: Rebecca J. Razo
Associate Editor: Emily Green
Production Manager: Nicole Szawlowski
International Purchasing Coordinator: Lawrence Marquez

Printed in China.
10 9 8 7 6 5
18597

CONTENTS

INTRODUCTION

"Is that really colored pencil?" People are amazed at what colored pencil artists are turning out these days. The good news is that you can create something wonderful too. Colored pencil art has caught the attention of gallery owners, publishing companies, the academic world, corporate art departments, and artists like you and me. Using a few simple and inexpensive tools, it is possible to create masterpieces. I am going to show you how to do that, step by step.

Flowers and floral portraits are excellent subjects to start with on your art journey. They can be brilliant and bold, whimsical, or subdued and serious. Best of all, they are very forgiving. Unlike faces and furry animals, flowers still will look lovely if you make color or structural mistakes. So let's begin the process of discovering what you can create with a few pencils and a sheet of paper!

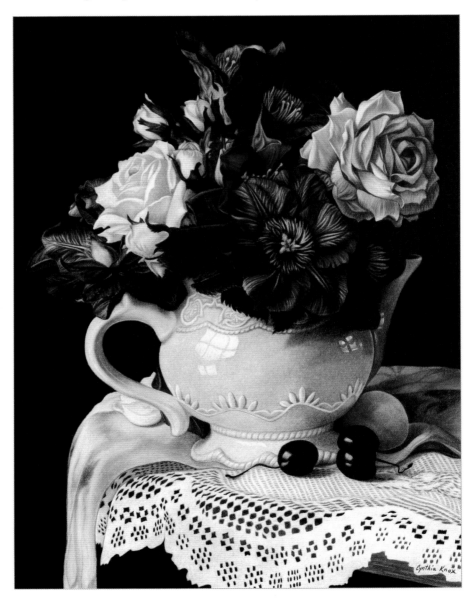

TOOLS AND MATERIALS

Colored pencil artwork is affordable to create and requires only a few supplies. However, I strongly rec-
ommend that you purchase the best quality materials possible. This is particularly important with your
pencils and paper. Student-grade pencils will not do, and cheap paper will tear halfway into your proj-
ect and leave you discouraged. So invest in the good stuff, and your artwork will last for many years
after you create it.

Pencils

You can purchase artist-grade colored pencils
individually or in sets at art and hobby stores
as well as online. There are three basic types of
colored pencils: wax-based, oil-based, and water-
soluble.

Wax-based pencils produce creamy, buttery
textures and are a joy to work with. Sanford
Prismacolors® are one of the most popular brands
and my personal favorite. They are sold in sets of
up to 132 pencils.

Oil-based pencils use oil in their binders rather
than wax. This results in fewer pencil crumbs
and less sharpening. Faber-Castell® Polychromos
(German) pencils as well as Caran d'Ache Pablo®
(Swiss) pencils perform well in this category.

Water-soluble pencils are bound with a water-
soluble gum. They lend themselves to watercolor
effects while still preserving the detail and preci-
sion of a pencil. Sanford Prismacolor and Faber-
Castell Albrecht Durer pencils are favorites.

You can use wax-based and oil-based pencils
interchangeably in your artwork; water-soluble
pencils are best for the projects meant to convey
a watercolor effect. I tend to prefer working only
with wax-based pigments because they are cream-
ier and easily build up to a painterly finish.

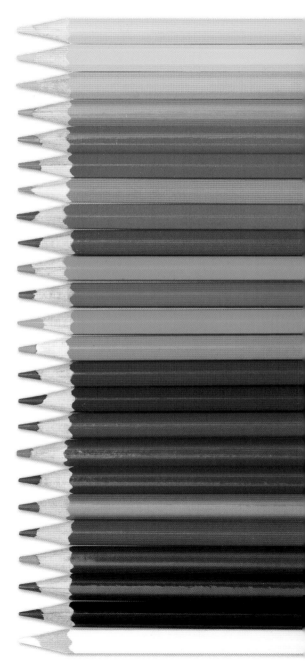

Paper

Art paper has "tooth," which determines how many layers of pencil you can put down before compromising the paper. If you like great texture and a "drawing" effect, I suggest cold-pressed paper. It has a slightly grainy surface and holds up well to erasing and applying many layers of color.

Rough-surface paper is even "toothier." It has obvious hills and valleys in its texture and is better suited to watercolor projects. It will grab a lot of pencil and wear down your points quickly.

My personal favorite is hot-pressed paper, which is extremely smooth and has very little tooth. This paper yields a painterly effect and is excellent for tight detail. I generally use Strathmore® Smooth (not Vellum) Bristol, which I purchase in pads. Another favorite is Canson® Smooth Bristol Museum Board, which has a stiffer surface.

Drawing Board

Drawing boards are portable wood boards with a clip at the top and an area cut out to use as a handle. I tape a blank piece of smooth paper down first and then tape my composition paper over that. The bottom layer provides padding for a smoother application of color. Either masking tape or artist's tape works well to secure the paper to the board.

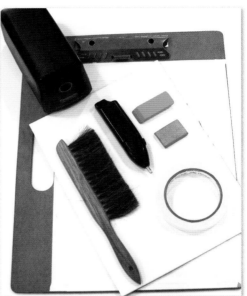

Pencil Sharpener

I've used an electric sharpener for the past two years. Occasionally, I'll sharpen a graphite pencil to clean off wax buildup on the blade.

Erasers

Colored pencil isn't easily erasable, but there are tricks to correct color mistakes or eliminate unwanted marks. A Pink Pearl eraser takes care of initial graphite sketch marks as well as smudges. A kneaded eraser can lift off layers nicely in an overly colored area. A battery-powered eraser will free your paper of pigment quickly, but it can wear down the tooth sooner than you think. Lastly, regular tape pressed down on the paper will also lift layers of pigment.

Drafting Brush

I keep two drafting brushes nearby. I use one to wipe off crumbs from the pencil point after sharpening and the other to brush my paper clean.

TIP

A drafting brush is crucial for sweeping away crumbs. However, some crumbs will inevitably embed themselves into the paper tooth. To eliminate them, sharpen a pencil and use the point to lift up the offenders. Use a pencil that is a similar color to the area where you need to remove crumbs.

COLOR BASICS

Colored pencils are transparent by nature, so you build color density by layering rather than mixing colors together on a palette. Understanding why certain colors work well together and why others don't is important. Color schemes create moods, and a chaotic visual can be turned into a calm one with just one or two color substitutions.

A color wheel, which you can purchase at an art store, makes it easy to revisit complementary color schemes.

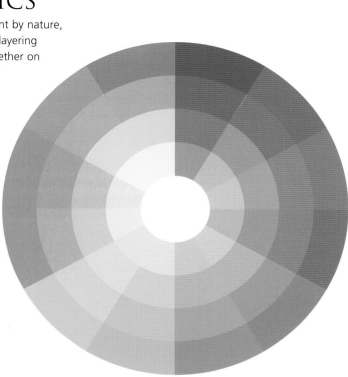

Types of Colors

Primary colors (red, yellow, and blue) are basic and cannot be created from mixing other colors. Secondary colors (orange, green, and purple) are a combination of two primaries. Tertiary colors (red-orange, red-purple, yellow-orange, yellow-green, blue-green, and blue-purple) are a combination of a primary color and a secondary color. Complementary colors are any two colors exactly opposite each other on the color wheel. Green and red, yellow and purple, and blue and orange are the main examples.

When placed together, complementary colors bring life to a composition and evoke strong responses from your viewers.

Color Temperatures

The temperature of a color refers to the warmth or coolness that it conveys. Half of the color wheel involves reds and yellows (warm). Blues and greens (cool) comprise the other half. A good thing to remember about color temperature is that warm colors appear to come forward, and cool colors appear to recede. You can use this knowledge to create depth and emotion in a drawing or painting.

COLORED PENCIL TECHNIQUES

Colored pencils are easy to work with and can produce a variety of textures, values, and tones. With an extensive supply of artist-quality pencils available, there are unlimited possibilities for color. You are able to layer, blend, burnish, and change colors to create the perfect palette each time. How? It really comes down to pressure, strokes, and color choices.

Pressure affects whether or not your artwork looks light and airy or glossy and polished like an oil painting. Strokes create texture, and you can expand your color choices with combinations of two or more pencils. As you practice, you will determine your own style and technique.

Pressure

You are able to control color intensity by how firmly you press the pencil point into the paper's tooth. I recommend starting with a light touch and then practicing with medium pressure and heavy pressure to create the most impact with your color.

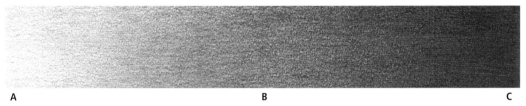

A B C

A) Light Pressure: I hold the pencil lightly and use airy strokes to create a transparent look.
B) Medium Pressure: By pressing more firmly, I achieve a layered effect. I stay in this zone of pressure much of the time.
C) Heavy Pressure: I use this technique to burnish and flatten the tooth of the paper.

Strokes

There are many different types of strokes for laying down color. How you hold your pencil and the direction of movement determine the outcome of your finished piece. Practice with the strokes shown here and become familiar with how wax- and oil-based pencils feel on different types of paper.

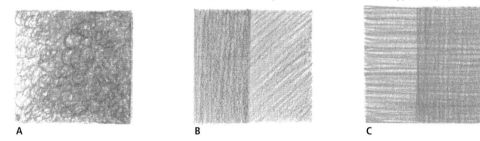

A B C

A) Circular: Move your pencil in a circular motion to gently build color.
B) Linear: Work vertically, horizontally, or diagonally to cover areas quickly.
C) Hatching: Create a series of parallel lines. Crossing over them from another direction builds density.

Layering and Blending

Colored pencil paintings are different from oil paintings. (The term "painting" refers to layering color upon color, which differs from a color drawing.) With colored pencils, unlike oil and other wet media, you do not mix colors on a separate tray. You build them up in layers on the paper, and the varying intensities of pressure determine color density and drama. The more pencils you use, the more color combinations you create. The stronger the pressure, the shinier and smoother the paper surface becomes as you wear down the tooth.

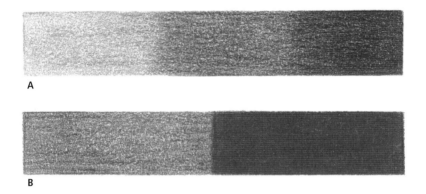

A

B

A) Layering: Very simply, apply one layer of color over another one. Continue this until you achieve the desired effect. Use light to medium pressure, a sharp pencil point, and smooth applications.

B) Blending and Burnishing: This is one of my favorite techniques. After I choose my color combinations, I sharpen my pencil point and really press down hard on that final top layer of color. Sometimes the point has to become slightly duller to avoid breakage. You can burnish with a colorless blending pencil, the last colored pencil you used in the area, or a white pencil, which lightens the overall appearance. Interestingly, this burnishing technique seems to melt or blend all of the colors into one beautiful look.

Using Fixative

I ultimately spray every finished piece with a workable fixative, which you can purchase at an art store. You can still make changes after applying, and the fixative will yield a lovely finish and prevent wax bloom. This refers to a waxy buildup that creates a filmy and unattractive surface. You can remove wax bloom by gently wiping the surface with a soft tissue.

To use fixative, first test the spray outside. Shake the can several times and spray it in the air to make sure it doesn't spit. Then hold the fixative about six to 10 inches away from your artwork and spray evenly. Repeat the process a second time. The spray is very toxic, so don't use it inside your home or around people or animals.

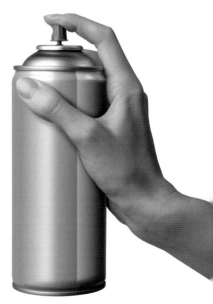

Determining Colored Pencil Choices

How do you know which colored pencils to choose to correctly match colors in your photo reference? This answer is easy with the use of two "value viewers," which Ann Kullberg, a leader in the colored pencil world, introduced. Because I use at least three different pencils to build up a section of color, I practice color combinations on another sheet of paper.

A value viewer is merely a two-inch piece of laminated white paper with a hole punched in the center. To begin, I place one value viewer's hole over an area of color in my photo. Then I make three to four pencil choices and layer them on the practice paper to try to match that color. I place the second value viewer's hole over the swatch I created and decide if I need a lighter or darker colored pencil or maybe something greener, redder, etc.

Value viewers help you select colored pencils to match your photo references.

I continue making swatches of color until the holes of the value viewers over both areas reveal similar colors. Then I write down the pencil names in the order that I used them. Remember, it's okay if your colors don't match perfectly.

Creating Compositions

Like artwork itself, composition is quite subjective. Some artists like to include a variety of objects in their setup, and others prefer extreme close-ups. In my personal experience, people seem to respond well to the following:

- **Strong visuals with definite focal points** are easy enough to create. Decide what it is you most want to draw or convey, and design your picture around that. For example, you may have a stunning and intricately etched vase that you would like to showcase. Find some flowers and a few other objects to include, and station them atop a surface that flatters the vase. Some artists like lace and linen, and some like the clean lines of glass, marble, or fine wood.
- **Colorful close-ups** are a favorite of mine. I enjoy using primary colors and punching up the drama with complementary colors. An example of this would be a cropped close-up of yellow and purple flowers with detailed centers and a blurred background.
- **Patterns** are appealing to the eye because of their repetitive nature. Floral subjects lend themselves well to this particular composition. Examples include rows of sunflowers in full bloom, a close-up of flower petals that are nearly identical, and perhaps a vertical composition of hanging flowerpots. The key is to have at least three objects in your design.
- **Obvious themes** require a bit more thought. What is it that you want to communicate? If it's a particular mood, such as joy or happiness, make use of brightly colored flowers. If you want to convey a calm stillness, try muted blues and greens. A darker palette can express grief and sorrow.
- **Beautifully lit subjects** are powerful. Who among us hasn't been impacted by the contrast of extreme darks and lights in one masterpiece and then moved by subtle lighting in another? I recommend getting ideas from photography books. They are invaluable as creative resources.
- **Triangular compositions** are pleasing to the eye. My friend Allan at our local art store has taught me much about this. In general, I establish my focal point (usually a vase, teapot, or bowl), which determines the height of the composition, and then I add smaller pieces like fruit on either side of the base. Perfect symmetry isn't always best, so it is a good idea to move the objects around until you sense that your design is complete.

REFERENCE PHOTOS

Like many artists, my camera is the tool I use to find great subjects to draw and paint. No matter how simple or sophisticated your camera is, you can achieve powerful visual effects with the use of a few simple tricks in a photography software program. I currently use Adobe Photoshop Elements to make common corrections, such as enhancing the color, sharpening any blurriness, and cropping. Sometimes I will also change a horizontal photo to a vertical one as shown here.

This photograph of yellow and red petunias was taken on a cloudy day. Believe it or not, that is the best lighting for flower photos. Sunlight can bleach out color and cause strong shadows, whereas diffused light, such as cloud cover, will yield more fully saturated colors.

To manipulate the original photo into the one I will draw, I crop the horizontal format into a vertical one to emphasize the flowers in focus. I also slightly enhance the colors, including "greening up" the leaves and buds.

TIP

I keep my left finger on my photo reference as I am drawing highly detailed areas so I don't lose my place. This is a very common problem, especially when drawing roses.

SKETCHING AND TRANSFERRING

There are many options available to transfer your subject image onto drawing paper. During my beginning years as an artist, I always used the freehand technique. Usually my finished work was okay, but I often had trouble with correct proportions. This led me to the grid method, which is a wonderful way to get proportions spot on. For several years this was all I used. Now I realize the value of using the projector method, which is quick, easy, and probably the best way to achieve perfect proportions.

Freehand With Transfer Paper

On a sheet of thin drawing or tracing paper, sketch out your composition until you are satisfied. Take a piece of transfer paper (sold in art stores) and tape it over the white paper surface you have chosen for your colored pencil project. There is a coating of graphite on the bottom of the transfer paper. Then tape your drawing or tracing paper over the transfer paper. Using a ballpoint pen or stylus, impress the outlines of your drawing with medium pressure. Raise both papers, and you will see the graphite image on your final white paper. Erase the graphite lines as you begin to color. Of course, you can always freehand your composition directly onto the final paper. Sketch lightly and erase well.

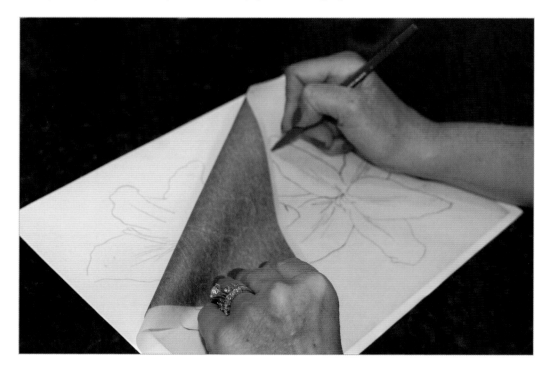

Grid Method

This method enables you to sketch out your drawing in small segments using one-inch squares. First photocopy your photo and draw a grid of one-inch squares over the photocopy with a pen and ruler. Then very lightly draw the same grid of one-inch squares with a graphite pencil onto your final drawing paper. Starting from left to right, draw what you see in each square. Connect your composition from box to box until it is done. Erase all your grid lines, and you're ready to start with colored pencils.

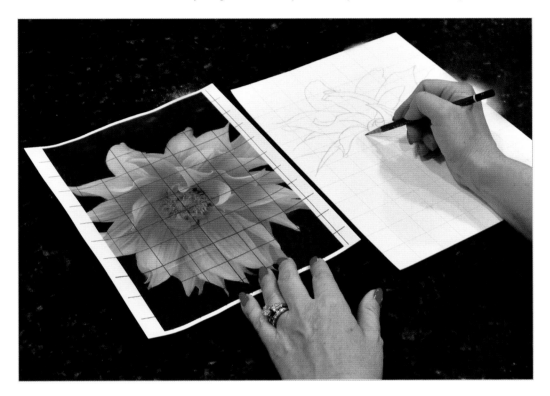

Projector Method

Secure your projector to a countertop and plug it in. Inside the top of it, there is a place to tape your photo, which then reflects off a lighted mirror, through a lens, and onto your final paper. After turning off the lights, trace the basic outlines of the photo onto your drawing paper. Once the sketch is on paper, you can then focus on creating a perfectly proportioned piece as you refine lines, add detail, and build up color.

FLOWER BASICS

You don't have to be a botanist or even a gardener to appreciate flowers. Their form, colors, and beauty inspire the artist within to bring them to life on paper or canvas.

Flower Types

There are about 190 types of flowers that florists generally use. This includes in-demand flowers, such as roses, lilies, orchids, tulips, and, during the holidays, poinsettias. Personal favorites of mine include roses, dahlias, lilies, and hydrangeas.

Flower Shapes

Within the National Audubon Society's nine color groups, there are five subgroups that reflect a flower's shape, including radially symmetrical flowers, daisy- and dandelion-like flowers, bilaterally symmetrical flowers, elongated clusters, and rounded clusters. A violet would be categorized as a bilaterally symmetrical flower, and a poppy would be placed within the radially symmetrical flower group.

Flower References

There are many books and websites available to help artists identify unknown flowers. One of my favorite books is the National Audubon Society's Field Guide to Wildflowers, which includes the color plates of each flower. Nine color groups comprise these plates: green, white, yellow, orange, brown, red, pink, purple, and blue.

Flower Anatomy

There are commonly four series of parts to each flower. The outside is called the calyx and is composed of sepals. Sepals are usually green but can be other colors as well. The interesting and most celebrated part of a flower is the corolla, which is the petal formation. It is the corolla that reflects a flower's symmetry. Within these petals are the stamens, which consist of filaments and anthers (to bear pollen). Lastly is the pistil, which is deep in the center of the flower and is responsible for the reproduction of seeds.

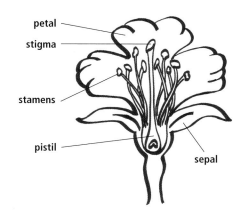

petal
stigma
stamens
pistil
sepal

Floral Art

Your artistic expression will evolve as you spend time outdoors taking photographs of all types of flowers. You will discover whether or not you like pale or vibrant colors, simple flower shapes or more complex and dramatic ones, and domestic or tropical bouquets. I encourage you to start simply and then experiment with those flower shapes that seem difficult to draw or paint. Just a few pansies and some late afternoon lighting in a local park inspired this pleasant composition.

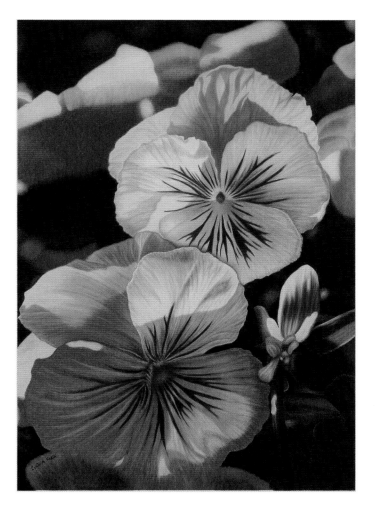

ROSE PORTRAIT

Vibrant flowers are visually pleasing to most people, especially artists, and roses are often the most exciting to draw. The broad outside petals inspire us to move into the center where the challenges lie. This is also where the viewer's eye is drawn. Roses may appear daunting because of these intricate petals, but success is simply a matter of proceeding step by step. Complete one small section at a time, and be patient with the process.

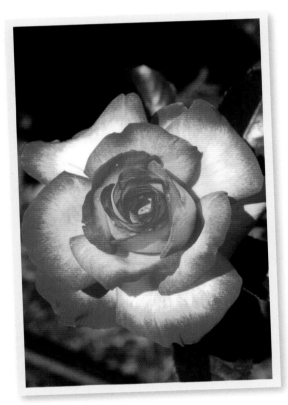

Black	Canary yellow	Cool grey 70%	Crimson lake
Crimson red	Dark green	Dark umber	Grass green
Pink	Process red	Pumpkin orange	Salmon pink
Sunburst yellow	Terra cotta	Tuscan red	White

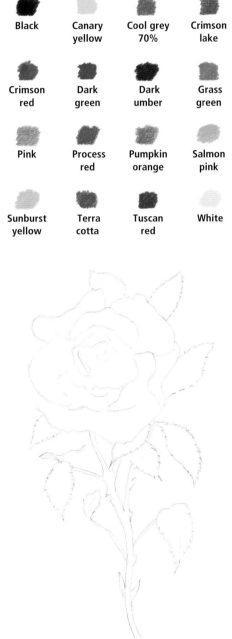

Step One I begin by lightly sketching the outside petals. This helps ensure correct proportions. I also outline the middle area but leave space to draw the tightly folded inner petals later on. Note that the photo reference does not show the leaves and stem you see here. I reference other pictures in order to free-hand them.

◄ **Step Two** After erasing the graphite lines until barely visible, I lightly fill in the outer petal edges with a layer of pink. Then I apply process red over the pink using a firmer stroke and following the curved lines of each petal. On top of that, I stroke in crimson red to create vibrancy and richness. The lower right petal now has all three colors.

► **Step Three** After layering pink, process red, and crimson red, I burnish each petal with white. A firmer stroke blends the three colors into one to achieve a painterly effect. I reapply process red and crimson red to darken some areas and cover the large white areas with my white pencil. With a very sharp point, I pull streaks of white down each petal. Prismacolor Verithin pencils work well for this step. The harder lead doesn't break easily.

◄ Step Four In the yellow areas, I begin with a light wash of salmon pink and then sunburst yellow. In the shadows, I lightly layer terra cotta and pumpkin orange and follow with an even softer touch of dark umber. Burnishing blends everything. Next, I redefine the red bud borders and fill in the small yellow spaces. I use crimson lake, crimson red, pumpkin orange, canary yellow, and sunburst yellow. Tuscan red darkens the interior. To finish, I darken the far right petal with Tuscan red, crimson lake, and white.

► Step Five I outline the light reflections in the leaves and keep them white for now. Next, I apply a layer of cool grey 70% using a medium firmness. I follow with black in the darker areas. Then I cover everything with dark green and burnish with white. In some areas, I add grass green to perk things up. I repeat the process until I'm satisfied with the blended look of each leaf. I clean up the edges with a kneaded eraser and lightly blend with white.

TIP
A white pencil with a very sharp point is invaluable in Step Four to both burnish and "erase" mistakes.

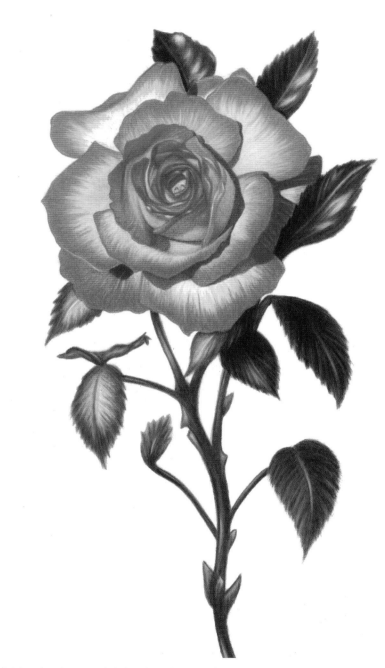

Step Six I lightly outline the stem with dark umber and continue filling it in with the same color. I leave some white highlights. I continue with terra cotta and burnish with dark umber. I use black to outline. For the leafy stems, I start with a light touch of dark umber and terra cotta, then add a bit of dark green. I burnish everything with white and repeat the process for intensity. Lastly, I clean up the edges with my kneaded eraser and spray with a workable fixative.

YELLOW DAISY

Presented against a background of purple petunias, the common yellow daisy appears more brilliant than normal. This brings us back to complementary colors. On a color wheel, the colors exactly opposite of each other are complementary. In this case, the complementary colors are purple and yellow.

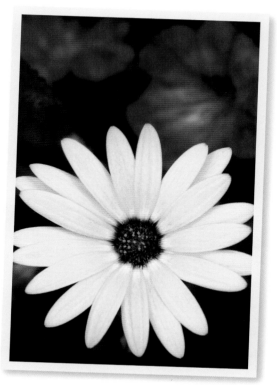

Black	Black grape	Burnt ochre	Cool grey 70%
Dark green	Imperial violet	Jasmine	Magenta
Mineral orange	Orange	Poppy red	Sunburst yellow
Tuscan red	Violet	White	Dark purple

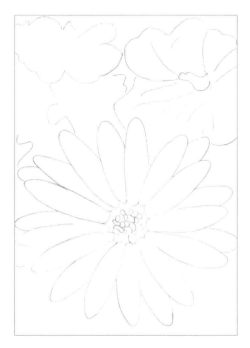

Step One I sketch the outlines of this floral portrait with the help of a projector. I outline the basic shapes with an H graphite pencil, which I will later erase because graphite shows through colored pencil.

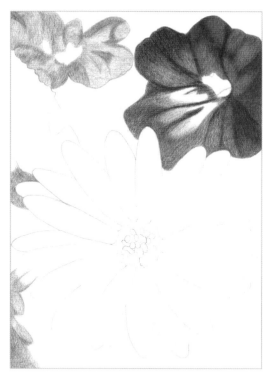

TIP
Small, rounded strokes
around all edges create
the blurred effect.

Step Two I start with the background because the finished colors here will determine which yellow combinations I choose. I outline the petunias with black grape and add a base wash of violet. I leave the lighter areas white. I concentrate on the petunia in the upper right and darken it with additional layers of black grape and violet in small, circular strokes.

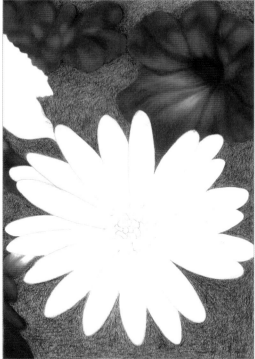

In Detail: In the dense black center of the petunia in the upper right, I use black, black grape, and Tuscan red with a final burnishing of black.

Step Three Still working on the petunia in the upper right, I add a touch of imperial violet and burnish with white. With violet and black grape, I darken select areas and add lines to form the petals. I finish the other background flowers with layers of violet, imperial violet, dark purple, and magenta, which also creates pink edges on the petals. I burnish with white and lightly use black for depth. Over the remaining background, with the exception of the green leaves, I add a light wash of black.

The term "wash" refers to a light application of color, generally the first layer.
On a scale of one to 10, use a light pressure of three to four for a wash.

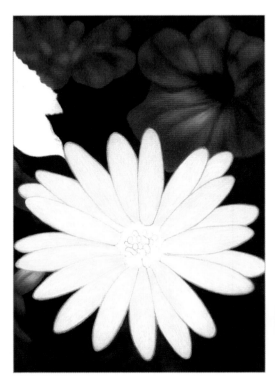

Step Four Continuing the background, I use Tuscan red then dark green with medium pressure. I use white over the lighter areas then reapply dark green. I finish with a black burnish over the darkest areas. I wash the daisy with jasmine and outline the petals with mineral orange.

Step Five I fill in the petals with sunburst yellow and a light layer of mineral orange. I burnish with white and add streaks of mineral orange. In the shadows, I lightly apply black grape, cool grey 70%, and burnt ochre. In the center, I start by erasing all graphite marks. Then I randomly scribble in the orange areas and apply poppy red on top. Next I form a few small splotches of burnt ochre and fill in all of the white areas with black grape, which extends into the base of the petals.

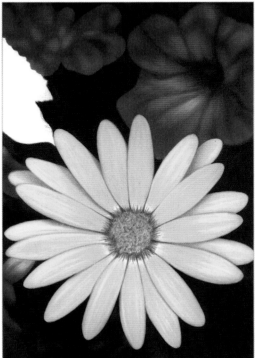

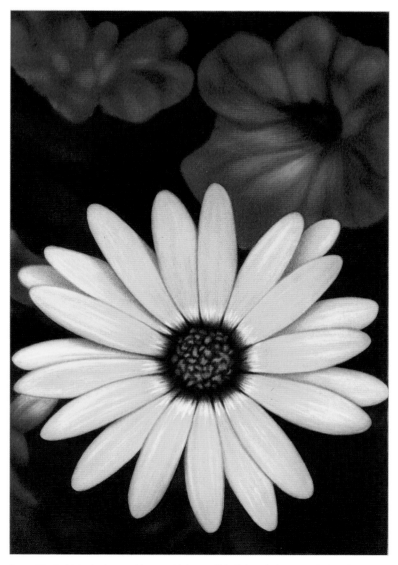

Step Six I add the background leaves with layers of black then dark green. I darken them beyond the reference photo by alternating between black, white, and dark green. I clean up the edges with my kneaded eraser then add several sprays of workable fixative to seal the piece.

In Detail: I use medium pressure to finish the center by layering black then dark purple over the black grape. I extend the dark purple into the base of the petals. Finally, I burnish with white then use sunburst yellow and mineral orange to pull streaks of color into the burnished area.

PINK PETUNIAS

When flowers are clustered together, it is important to identify a focal point. In this case, it's the large petunia in the foreground. Manipulating the lights and darks in the composition will help set it apart, and so will lightly outlining the flower.

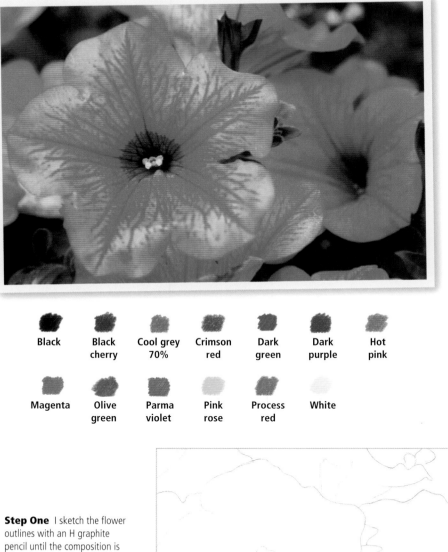

Black	Black cherry	Cool grey 70%	Crimson red	Dark green	Dark purple	Hot pink

Magenta	Olive green	Parma violet	Pink rose	Process red	White

Step One I sketch the flower outlines with an H graphite pencil until the composition is complete. I will later erase these lines as I apply color.

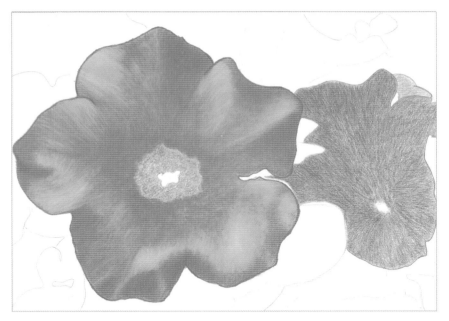

Step Two I outline the main petunia with process red and then wash the entire flower with a layer of pink rose. Using medium pressure, I layer hot pink and process red over the pink rose. I use broad circular strokes, and I finish the basecoat with a white burnish. I then burnish the lighter petal areas with white and build up the darker areas with process red. I start on the flower to the right using hot pink and then process red. My strokes follow the direction of the petals.

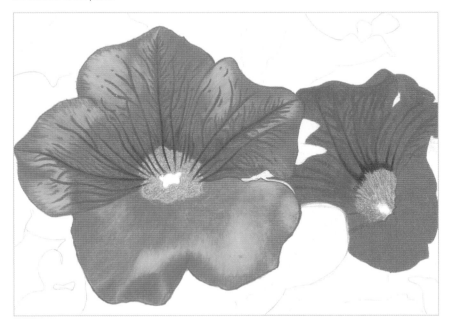

Step Three Using magenta with a sharp point, I draw the longest line down the middle of the center petal. Then I draw the lines to the left and right. I lightly apply black cherry over some of the longer lines for depth. Then I use crimson red to fill in the red areas around the center. After finishing half of the main flower, I switch to the flower on the right. I build color with magenta on the top half and process red on the bottom. Over the top half, I use crimson red in the striated red areas and black cherry for the lines leading into the center.

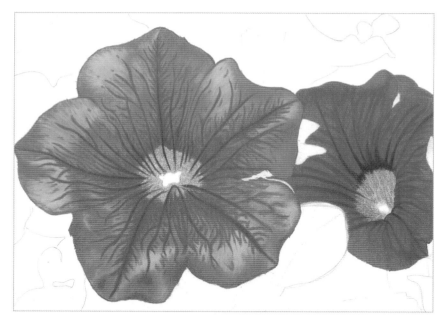

Step Four I finish the magenta lines in the large petunia's petals and darken them slightly with black cherry. Then I fill in the circular area outside the center with crimson red. I touch up the exterior petals with white in the light areas and magenta in the dark. I finish the petunia on the right by drawing the remaining crimson red striated areas, which I enhance with black cherry. I use crimson red to canvas the red areas and process red to brighten the hot pink lower petals.

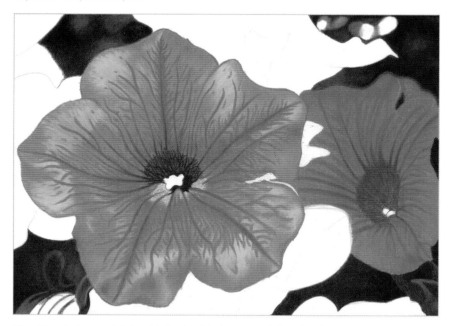

Step Five In the upper left, I use black to block in the extreme darks and cool grey 70% as a basecoat for the lighter greens. Over both areas, I apply dark green with medium pressure and then burnish a second coat. I repeat the process in the lower left. Moving to the upper right, I use black and dark green to replace the dark grey area in the photo. For the bright spots, I use white with olive green. I finish the bottom right with the same pencils. In the main petunia, I burnish the top half of the center with crimson red and randomly place the thin, lacy lines of black. In the petunia to the right, I layer black cherry in the center.

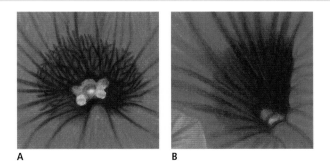

A B

In Detail: I finish the main petunia's interior (A) with a burnish of process red and then white, as well as black for the lines. For the bright center, I use dark green, hot pink, black cherry, and white. I finish the interior of the petunia to the right (B) with black in the darkest areas, crimson red between the striated lines, and parma violet in the purple areas. Then I apply dark green in the inner circles with a burnish of white.

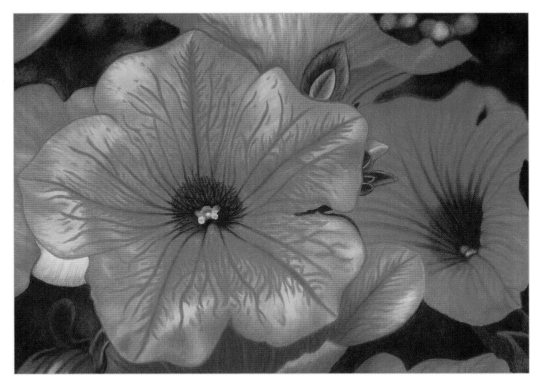

Step Six I complete the background petunias using the previous pinks and reds. I shadow the bottom petal with dark purple to create contrast. Then I substitute leaves for the shriveled petal behind the main petunia in the photo using black, dark green, olive green, and white. I also use hot pink and process red with white to complete the background highlights.

JOHNNY JUMP-UP

This project is a good example of improvising on a photo's composition. While the blurred background is attractive and brings this Johnny Jump-Up forward, there needs to be something to anchor the flower besides the thin black stem. In the painting, I add a leaf on the right of the stem and bring more detail to the two existing leaves on the left. This separates the focal point from the background.

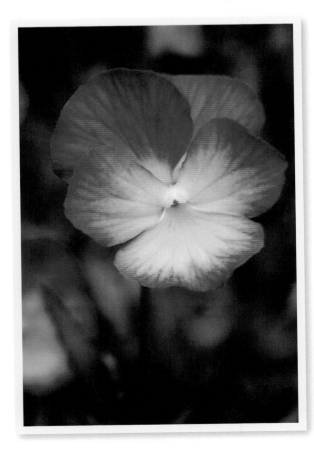

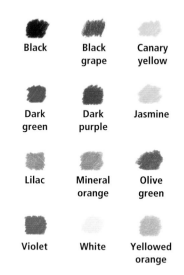

Black	Black grape	Canary yellow
Dark green	Dark purple	Jasmine
Lilac	Mineral orange	Olive green
Violet	White	Yellowed orange

Step One I outline this simple composition with violet for the flower and dark green for the leaves. There is not much to this sketch, so there is little risk in outlining it in color rather than graphite.

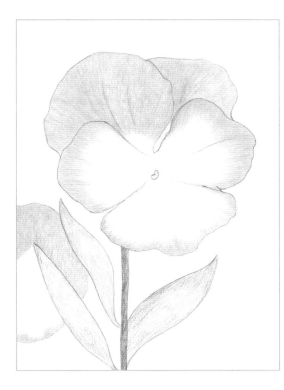

Step Two I apply two washes of lilac with light pressure on the main and background flowers. I leave the yellow areas white. A light coat of black covers the stem and two of the leaves. I wash the upper leaf on the left with olive green.

Step Three Beginning with the largest petal, I layer violet, then dark purple, and, finally, a burnished coat of white. I stroke in the direction of the petal's lines. Then I repeat the process to intensify the color. I draw the individual petal lines in dark purple and add violet on top in the darker areas. Black grape is the base color for the deepest hues at the petal's edge, and I layer violet and dark purple over that. I use white to lighten where necessary. Then I layer the small upper petal with lilac, dark purple, and violet. After a white burnish, I draw in the lines with violet.

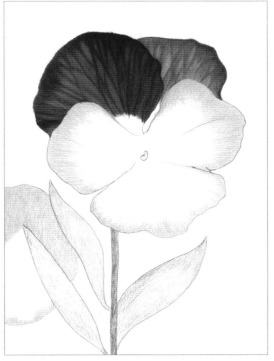

TIP

To determine if my colors are too dark, too light, or just right, I squint my eyes and compare the photo to my painting. This helps to identify where changes may need to be made.

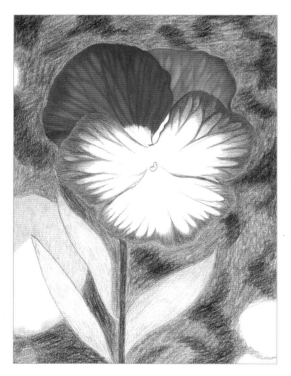

Step Four I lightly draw the purple areas of the remaining three petals with violet and dark purple. I block in the dark background with black, dark green, and then olive green. I do this by making random splotches of black and green over the entire area. It has a childish appearance now, but, after burnishing, it will be a nice blended background.

Step Five I burnish the entire background with olive green using small rounded strokes, a sharp point, and firm pressure. I tightly swirl dark green over randomly chosen areas and finish the blurred, smooth look with a sharp but soft black. I clean up smudges inside the flower with an eraser and wash the yellow center with jasmine. I lightly layer lilac over the elliptical areas around the flower. Then I use white to burnish and blend the colors.

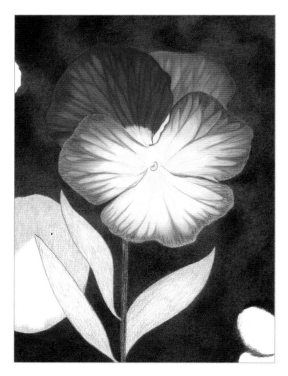

TIP

Once an area is highly burnished and slick with color (four coats or more), you can draw over and completely remove incorrect lines or shading with a sharp white pencil.

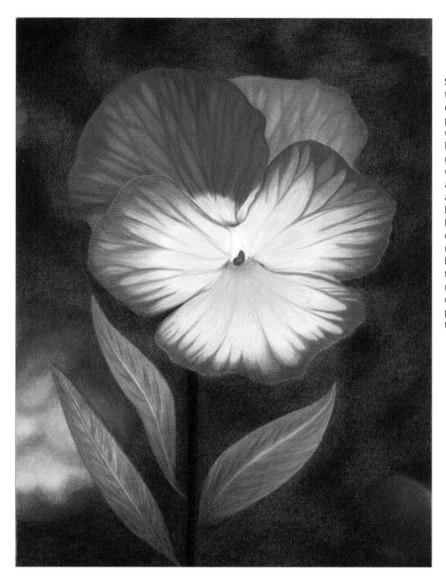

Step Six I complete the petals' outside edges with dark purple, violet, and white. I finish the leaves with dark green and then with olive green and white. I lightly add black at the base of the leaves. I continue with the colors previously used to finish the blurry flowers in the background. I use circular strokes of white with firm pressure to blend it all together.

In Detail: I develop the petals' bright areas of yellow using canary yellow, and I use yellowed orange for the inner part of the lowest petal. In the center, I burnish mineral orange over the small half circle and add dark purple for depth. I repeat the entire process and finish the yellow center with a burnishing of white. Then I add dark green between the petals and in the deep center.

YELLOW ROSE

The photo of this lovely yellow rose reveals a singular water droplet on the lower petal. Raindrops and dewdrops give flowers a fresh appearance, and they are quite simple to draw. In this project, I add a second drop for balance and symmetry.

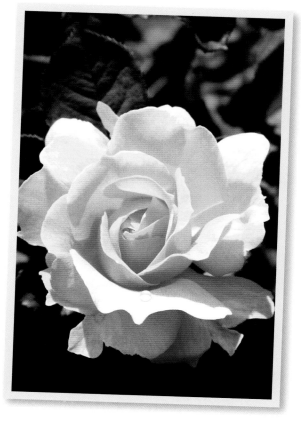

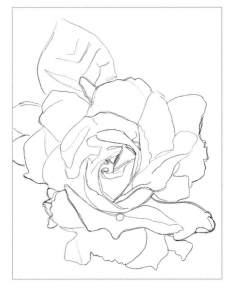

Step One The sketch above appears in graphite so you can see the lines easily. However, I actually begin this project by outlining the rose with yellowed orange so that no sketch lines will show through the transparent color.

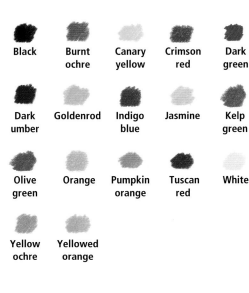

Black	Burnt ochre	Canary yellow	Crimson red	Dark green
Dark umber	Goldenrod	Indigo blue	Jasmine	Kelp green
Olive green	Orange	Pumpkin orange	Tuscan red	White
Yellow ochre	Yellowed orange			

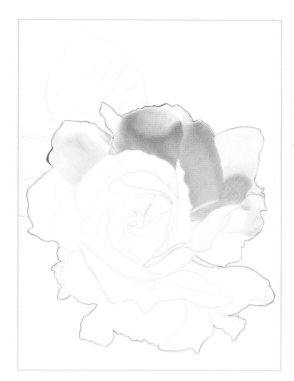

Step Two I outline the exterior of the rose with black to establish the background edging. I layer the large top petal with jasmine and yellowed orange. Then I add orange in the dark areas. With yellow ochre and then a burnishing of white, I complete the basecoat. Then I use pumpkin orange and a touch of crimson red in the reddish areas. I blend canary yellow over the entire petal with firm pressure. I use yellowed orange to build up the orange areas and white to lighten. I lightly shadow the base area with burnt ochre. Then I add jasmine and white highlights with touches of yellowed orange and canary yellow.

Step Three Still working on the outer petals, I build up the shadow areas with burnt ochre and blend with yellowed orange and canary yellow. These three pencils, along with pumpkin orange and orange, create the remaining petals above and around the center. For the bright reddish areas, I add a crimson red topcoat. Then I use dark umber on the left petal, and burnish everything with white.

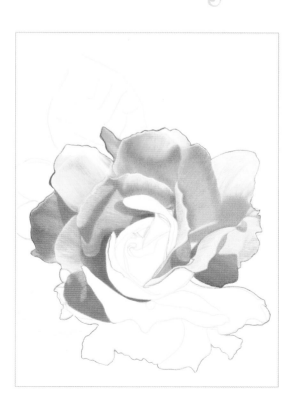

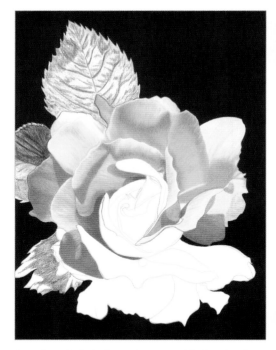

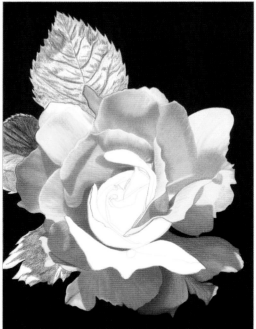

Step Four In the background, I create a rich, dense hue first with black, then Tuscan red, indigo blue, and a final burnish of black. I give the background leaves an initial coat of black using light pressure.

Step Five On the lower left petals, I follow a jasmine wash with pumpkin orange. Then I apply orange, crimson red, yellowed orange, and canary yellow. For the highlights, I use jasmine, white, and pumpkin orange. To the right of that, I gently apply dark umber in the shadows, and I complete the bottom recessed petal using goldenrod with light streaks of crimson red and pumpkin orange. To finish the remaining back petals, I add burnt ochre and goldenrod, as well as a light application of dark umber for the shadows. Touches of dark green and crimson red bring the petals to life. I also add highlights with jasmine and white.

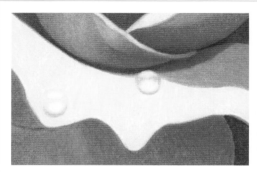

In Detail: I lightly outline the water drops and fill them in with goldenrod. Then I blend them down using white.

In Detail: I finish each leaf by layering dark green, kelp green, and olive green over the existing black. Then I add black back in and burnish with white for highlights.

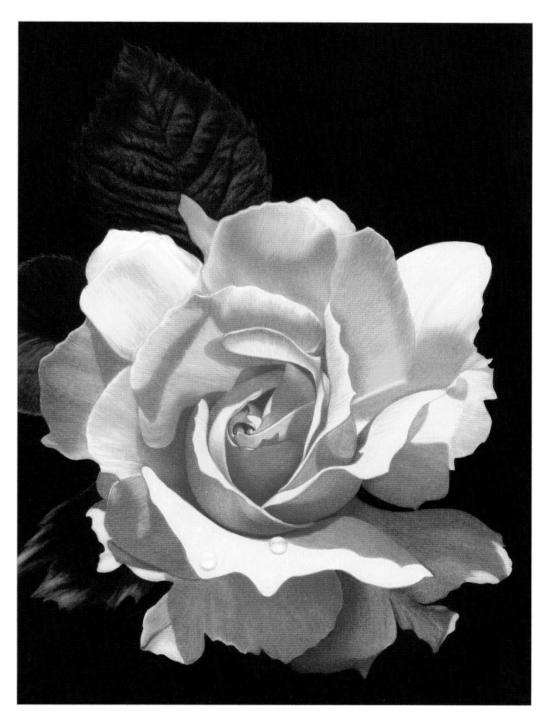

Step Six I add jasmine and pumpkin orange at the bud's base. Next I layer yellowed orange over both sides and cover the red area to the left with Tuscan red. Then I use crimson red with a light, circular touch on both sides of the bud and canary yellow for the yellow areas. The interior of the bud is like a puzzle, and I complete it one piece at a time. For the orange areas, I use yellowed orange, pumpkin orange, orange, and finally crimson red. I deepen the shadows and crevices with Tuscan red, and I color the light yellow areas with canary yellow and white.

CASABLANCA LILIES

The simple act of cropping a photo can add immeasurable impact to your artwork. When you eliminate the background, you bring the focal point front and center and generate excitement. You are also able to observe more detail and a broader range of color. Note the initial photo of these two Casablanca lilies. With successive cropping, the composition transforms from basic to big and exciting.

| Black | Black grape | Bronze | Crimson red | Dark purple | Kelp green | Rose |

| Magenta | Moss green | Pink | Violet | White | Yellow ochre |

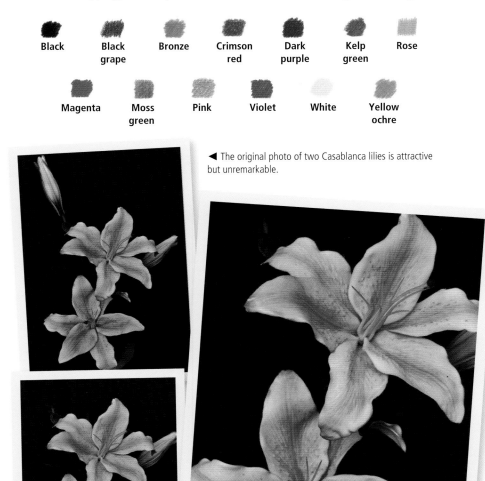

◄ The original photo of two Casablanca lilies is attractive but unremarkable.

The first crop brings the flowers to the center of the frame.

The final crop brings the viewer within inches of those beautiful petals.

TIP

Don't be afraid to crop your backgrounds out and place full attention on your subject material. Your audience will appreciate it.

Step One I sketch the outlines of the lilies with my rose pencil and resist the urge to put in any detail at this stage. That will come later.

Step Two I apply a wash of pink over the entire top flower. Directional strokes and a light touch are important here. Using firm pressure, I use white to burnish each petal and establish a smooth basecoat.

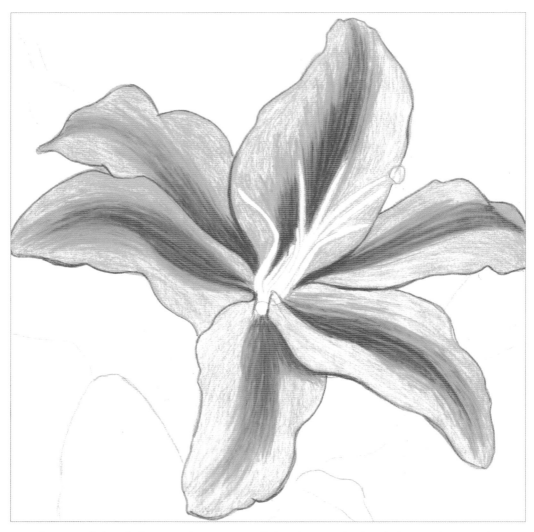

Step Three Over the burnished areas, I apply magenta vertically down the center of each petal. Then I streak crimson red over that and follow with a burnish of white.

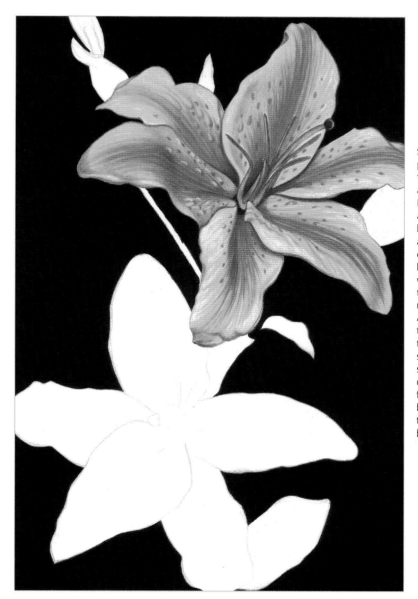

Step Four Using my pink pencil, I draw in the lighter, thinner veins on each petal and burnish with white. Beginning with the top petal and moving clockwise, I then blend and layer with magenta and white. In the darker contoured areas, I lightly use black grape and soften that with white and pink. I apply the dark pink spots with magenta and crimson red. A hard white pencil point in tight elliptical strokes creates these raised bumps. A final, soft burnish of white with small strokes blends the overall appearance. I also fill in the background with black grape, then violet, and, to finish, a firm pressure of black to burnish.

In Detail: I layer the stigma with black grape and kelp green and top it with crimson red. Then I create a contrasting outside edge in white. I color the stamens and pistil with kelp green and moss green and blend with white.

Step Five I layer all petals of the bottom flower twice with pink and then add a white burnish. Beginning with the top petal, I block in the dark pink color with magenta and the shaded area with black grape. I use white to blend, and I layer and burnish with magenta and white to establish a nice basecoat. I draw the lines of the petals in magenta and pink. Then I add some white lines between the pink ones. Finally, I use kelp green for the inner green area and repeat the entire process for each petal.

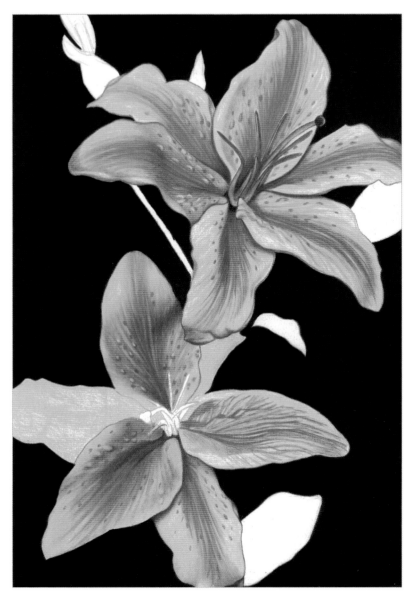

In Detail: I apply the red dots on the petals of the lower flower with crimson red and surround the white raised bumps with black grape.

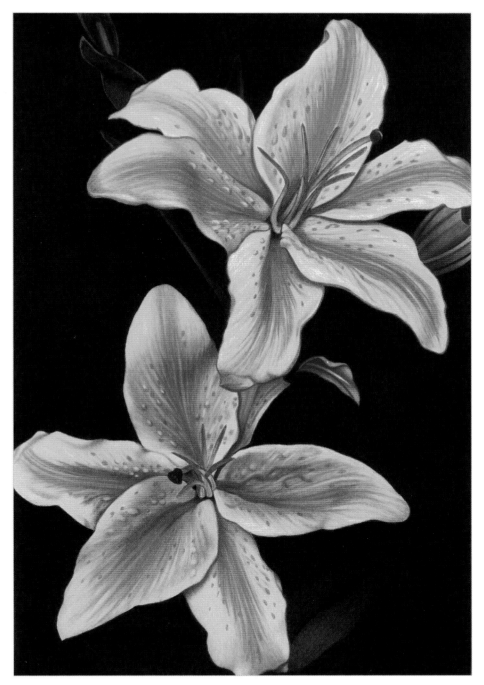

Step Six I layer the lower leaf with black and kelp green. I add white for the lighter area and finish with moss green. I shadow the small petal in the middle with black grape and magenta. Then I burnish with white and add crimson red. I create the striped bud in the upper right using moss green, kelp green, and bronze for my greens. The pinks consist of pink and magenta with crimson red and dark purple to deepen the hue. Then I apply yellow ochre for the yellow stripe. I burnish the entire bud with white and lightly apply black grape at the base with a sharp point. In the upper left, I create the remaining foliage with a black basecoat topped with kelp green and moss green. With white, I outline the edges and lighten selective areas. Finally, I finish the petals on the lower flower as well as the stamens, pistil, and stigma.

PARROT TULIPS

Bright colors, such as these yellows and reds, go well together in the garden and on our drawing canvas. For a dramatic presentation such as this, only a black background will do. Black showcases the vibrant colors as well as the black and green centers and keeps the composition simple yet stunning.

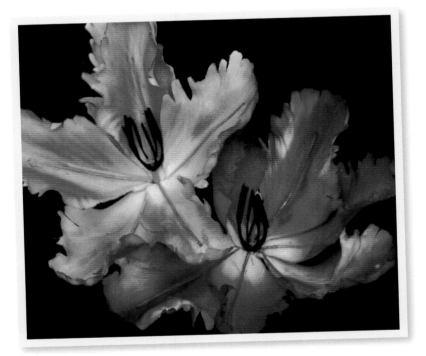

Apple green

Black

Canary yellow

Crimson red

Dark green

Indigo blue

Mineral orange

Orange

Pink

Poppy red

Pumpkin orange

Scarlet lake

Sienna brown

Sunburst yellow

Terra cotta

Tuscan red

White

Yellow ochre

Yellowed orange

Step One The sketch above appears in graphite so you can see the lines easily. However, I actually begin this project by outlining the two parrot tulips in yellow ochre using medium pressure.

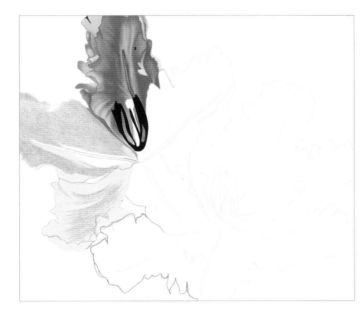

Step Two Singling out the top left petal, I wash it with yellowed orange then orange. I selectively apply crimson red and blend with yellowed orange. After a white burnish, I restore intensity using the same pencils, plus poppy red and pumpkin orange. Sienna brown lines the vein, and canary yellow brightens the streaks. For the back of the petal, I use yellow ochre then canary yellow. For the sides, I use orange, poppy red, and crimson red. I add terra cotta to the dark area on the right. Then I lightly wash two additional petals with sunburst yellow then orange.

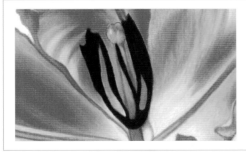

In Detail: A burnish of black tops indigo blue on the stamens. On the pistil and stigma, I start with a light coat of dark green and follow with apple green and a white burnish. Repeat this process once you are working on the second flower.

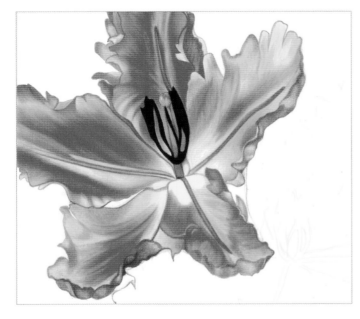

Step Three I top the established basecoat of the middle left petal with yellowed orange and poppy red, as well as streaks of crimson red. I burnish with white. Then I add terra cotta shadows and layer canary yellow over the reds. White burnishes the pink center.

Step Four I layer canary yellow over the lower left petal. Then I layer poppy red, orange, and crimson red in the orange areas. I finish with a firm burnish of white. I layer mineral orange over the upturned petal ends. I use sienna brown in the brown areas and crimson and Tuscan reds in the red ones. The green edge gets a white burnish over dark green, crimson red, and canary yellow.

Step Five I start with canary yellow then sunburst yellow for the final two petals. Poppy red and crimson red comprise the reds with touches of orange and sienna brown in the veins. I burnish with white and add dark green and apple green for the outer edges.

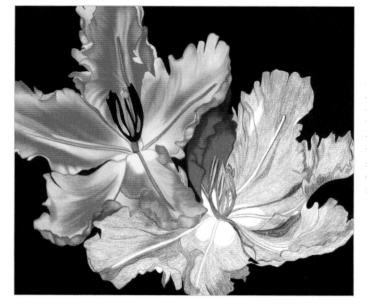

Step Six A black background is a wonderful setting for these dramatic tulips. I use my favorite palette of black, Tuscan red, and indigo blue. I finish with a burnish of black. Then I establish the basecoats on the second tulip with scarlet lake and crimson red, a light coat of black, and apple green. Crimson red is my main pencil for this flower.

TIP

Blending and burnishing are the keys to finishing this project. Treat each section like a small puzzle piece and use one of your reds, oranges, or greens to blend. Then burnish with white and finish with a final top color.

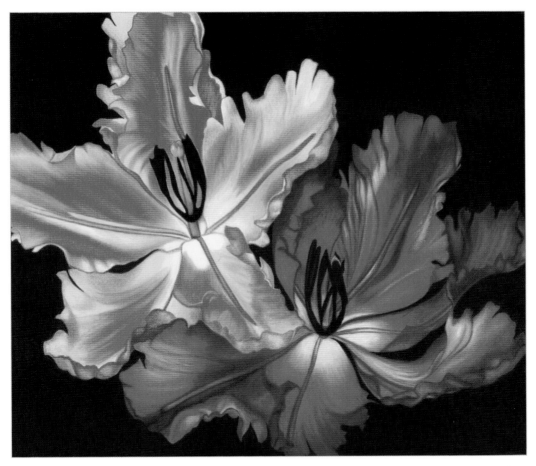

Step Seven I finish the petals with poppy red and orange topped with crimson red. I burnish some of the black basecoats with white to lighten. Then I reapply crimson red and add Tuscan red to the shadows. I finish the greens with dark green, then apple green, and a white burnish. I bring out a few of the yellow highlights with canary yellow. Then I use orange, terra cotta, and white on the center veins. I erase all smudges and spray with a fixative.

PASSION FLOWERS

While it's always easier to simply draw one or two flowers, you can also include other items of interest for the viewers' pleasure. Here we have interesting leaves and something that looks like a corkscrew to add a little texture. Always keep your eyes open for unique ways to enhance your masterpiece.

Step One I sketch my composition in cool grey 70%. The neutral color will work well with the blues and greens in this piece.

Apple green	Black	Black grape	Blue violet lake	Cool grey 70%
Dark green	Dark purple	Dark umber	Imperial violet	Indigo blue
Kelp green	Mineral orange	Orange	Pale sage	Tuscan red
Ultramarine	Violet	White		

46

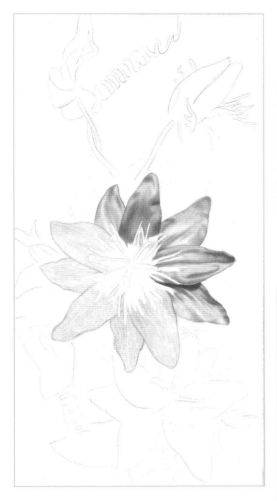

Step Two The main center flower is my starting point. I begin with a light wash of blue violet lake. Then I work clockwise from petal to petal. My palette is simple: Imperial violet and violet for the purples; ultramarine for the blues; cool grey 70% for greys and to darken; and a lot of burnishing with white. I also use apple green for the interior. I layer, reapply, and burnish until I am pleased with the effect.

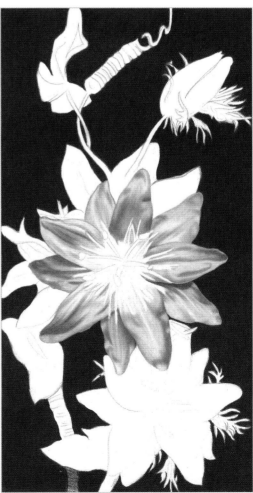

Step Three I finish all of the petals on the main flower and choose to complete the background before I determine how light or dark my flower centers will be. My favorite formula for a black background is: First, black with medium pressure; second, Tuscan red and indigo blue with medium pressure; and, finally, a heavy burnish of black. This yields a rich, densely black backdrop.

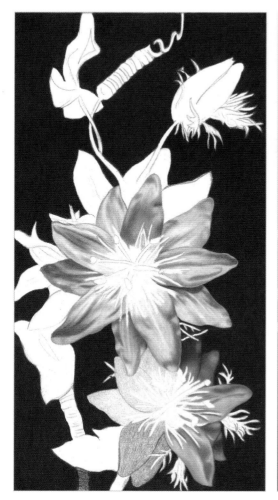

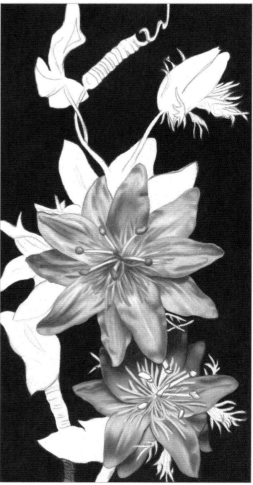

Step Four Moving to the lower flower, I re-draw the individual filaments. Then I apply a wash of blue violet lake. Beginning with the very top petal, I layer the dark area with black then ultramarine. A light burnish of white with apple green at the base completes the petal. I layer the next two petals with ultramarine and white. I use black grape as an undercoat to darken the heavy blue area and apply ultramarine over that.

Step Five To complete the last petals on the lower flower, I layer ultramarine and follow with a white burnish. This creates a sleek foundation upon which to build vibrant color. To punch up the blues, I use violet and reapply ultramarine. For greater depth, I use black grape and, in the very darkest areas, pure black with a light touch.

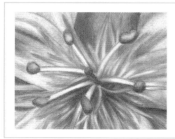

In Detail: To create both flower centers, I define the stamen shapes with pale sage and draw a lot of overlapping strands, also with pale sage. I color in between the strands with kelp green. To add depth, I use cool grey 70% over the kelp green in random areas and burnish lightly with white. I use violet on the ends of the strands and color the stamen tips, known as anthers, with orange and then Tuscan red.

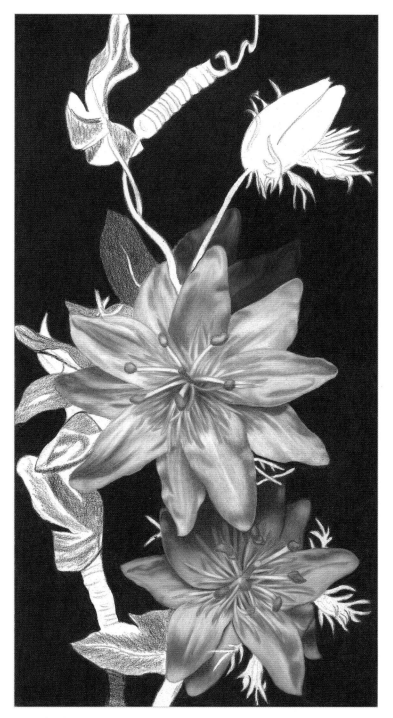

Step Six The many green leaves in this composition all begin with a light wash of black in the darker areas. Concentrating on the leaves around the top flower, I continue by layering dark green over the black. I use white to burnish in the light areas and to blend overall. Then I reapply dark green where needed and use black as the finishing touch in the shadows and veins.

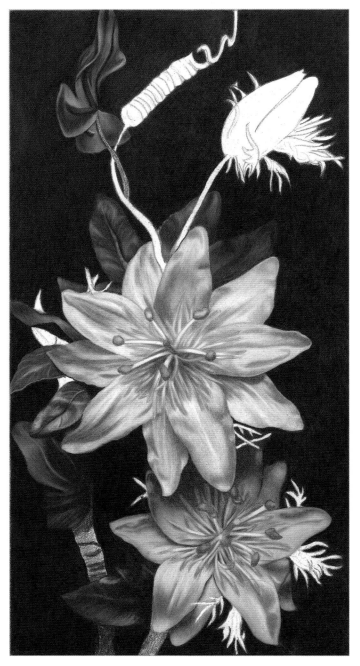

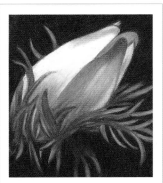

In Detail: I render the closed bud first with a coat of white. Then I darken the right side with layers of black grape and white, as well as dark purple for the darker petal tip. Apple green and white complete the bud. I use dark green, kelp green, and white for the strands of greenery, plus dark umber in the shadows.

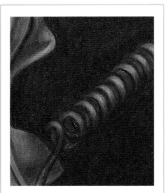

In Detail: For the corkscrew shape, I outline the circular shapes in black. Then I use dark green, mineral orange, and white to create the shiny loops. I layer black and white in the interior spaces. At the base of each loop, I burnish with black to complete the corkscrew shape.

Step Seven I complete the remaining leaves with dark green on top of the black basecoat and use white to blend. I repeat the process to build density and contrast as well as to create smooth surfaces. Then I use dark umber and dark green for the darker leaf veins and apply black for the defined vein edges. I lightly use dark umber to block in the lower stems.

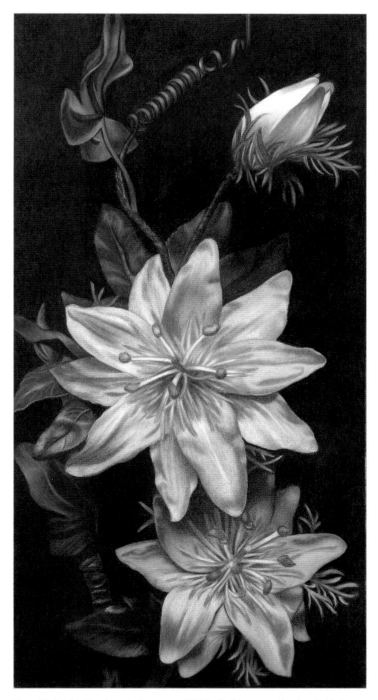

Step Eight Working from the bottom up, I finish all of the stems. First I apply black using heavy pressure for the darkest areas and medium pressure for the rest. Dark umber with black and white completes the brown stems. For the background leaf in the middle left, I use dark umber, kelp green, and white. Then I use dark green, kelp green, and white for all of the strand-like greenery around the flowers and dark umber for the shading. Finally, I erase all of the smudges and spray the piece with fixative.

PINK DAHLIAS

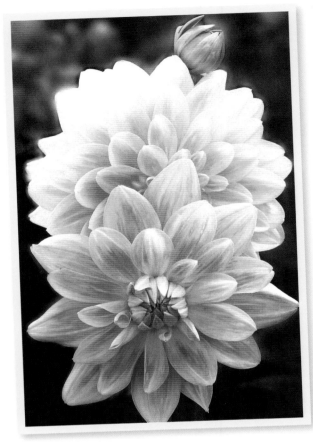

These two beauties from an Irish castle garden appear complex at first. However, because of the similar pattern of the petals, this composition is quite manageable to complete, albeit time consuming. The important thing is to take one step at a time, one petal at a time. It won't be long before you reach the end and realize the time investment was well worth it.

Apple green	Black	Black grape	Canary yellow	Cool grey 70%
Crimson red	Dark green	Dark umber	Kelp green	Mineral orange
Moss green	Olive green	Parma violet	Pink	Process red
Tuscan red	White	Yellow ochre		

Step One I sketch out the two dahlias in pink.

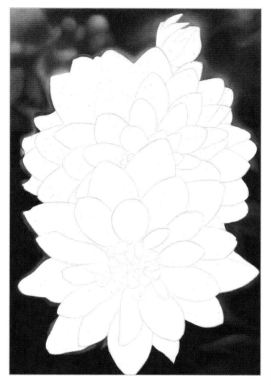

TIP

Laying down dark
backgrounds always
results in smudging on
the white paper, so a
good eraser is necessary
to reclaim clean surfaces.

Step Two The majority of the background is dark green,
so I first layer a coat of black with medium pressure almost
everywhere and then apply dark green over that. I use white to
bring forth the lighter shapes on the right. I repeat the process
until I achieve a good photo likeness. Moving to the top, I use
crimson red with black grape to darken the reds. For the pinks,
I use pink and process red with black grape to darken. For the
greens, I use dark green, apple green, white, and black. I blend
to attain a blurry, soft look using light pressure with my white
pencil in small, tight circular strokes.

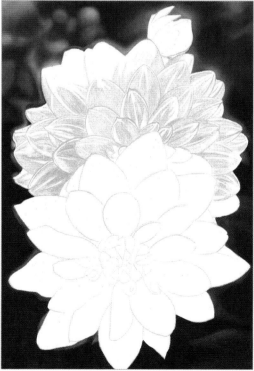

Step Three Using my pink pencil, I lightly wash the top tier of
petals with vertical strokes.

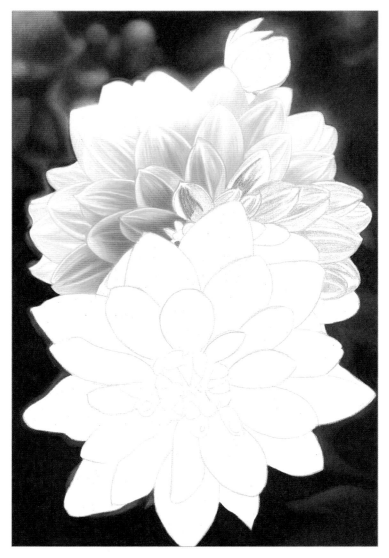

Step Four I make a few minor changes in the background colors by darkening several areas. Then petal by petal, I detail the top flower. I layer white several times over the white areas. I reapply pink and layer process red and crimson red on top to darken. Then I burnish with white for a smooth, painted effect.

TIP

To restore a true white in a previously colored area, first try a sharp white pencil. If that doesn't work, dab the area with a white oil pastel. Leave this step until the end in order to keep pencil crumbs from sticking to the pastel.

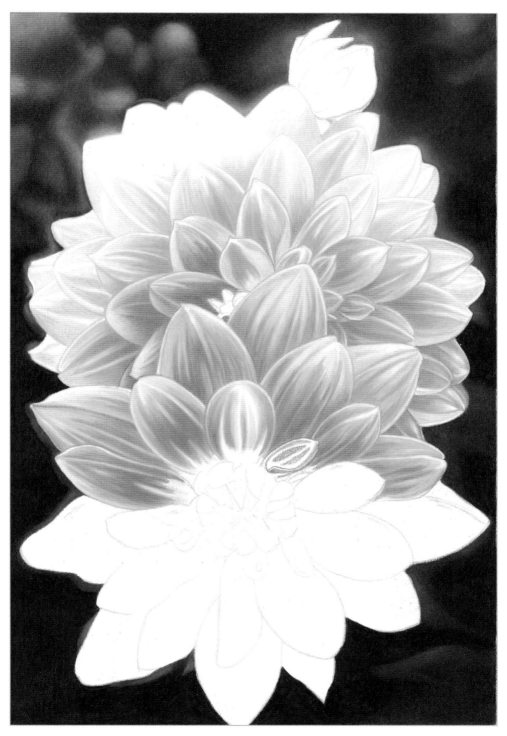

Step Five I continue working on each petal using pink as my foundation and process red and crimson red for the deeper colors. White burnishes and blends the colors together. I enhance the reds and dark pinks in many of the petals. I also use yellow ochre inside the two left petals on the lower flower.

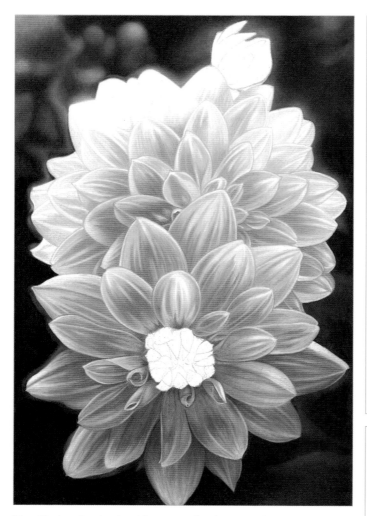

In Detail: For yellow or green areas near the flower's center, I apply a wash of yellow ochre followed by moss green, yellow ochre, and mineral orange. I use kelp green for the dark greens and striations. Moss green is my finishing layer. I add cool grey 70% over the greens in the shadow areas. In some areas, I pull the pinks and reds back into the green. With a light touch of black, I fill in the small crevices around the center.

Step Six I continue layering pink, process red, and crimson red and burnishing with white over all of the petals on the lower flower. I repeat the process several times. The bottom half is shadowed, and I convey the darker colors with several sharp and very fine applications of Parma violet and cool grey 70%. A light touch of white smooths out everything. I use a very sharp white point for the edging of the tightly curled petals and Tuscan red to deepen the shadow areas and outline the petals.

In Detail: I redraw the flower's center and work in a clockwise direction. I wash the lightest petals with pink and burnish with white. I use process red to fill in the bright pinks and Tuscan red to line most of the petal edges. Black grape deepens the shadowed areas, and I use black sparingly in the very darkest nooks within the center. With olive green and a little Tuscan red, I finish the green edging.

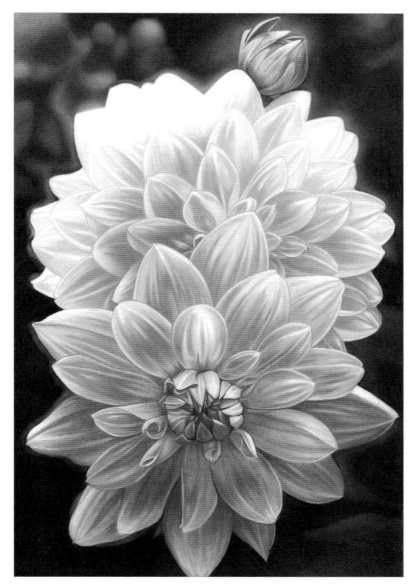

Step Seven I finish the green background around the closed bud with black, dark green, and white. I review the finished piece for embedded crumbs or incomplete colors, then erase smudges, and finish with a fixative spray.

In Detail: I lay down a yellow ochre wash from the base of the bud to nearly halfway up. I follow with canary yellow, white, and olive green in the green areas. A light edging of black separates the base of the bud from the pink petal below. Then I apply dark green over the green area and yellow ochre over the yellow. I wash the upper area with pink and apply process red on top. I use white to blend. From left to right, I use crimson red and Tuscan red in the darker areas. Parma violet shadows all of the pink petals, and Tuscan red creates the edges. Then I darken the far right area with a feathered coat of dark umber and a blending of mineral orange.

LAST DAYS OF SUMMER

Working from photo compositions, it is important to decide whether or not to include every single thing in your art piece. Changes can be made; artistic license employed. In this project, I choose to brighten and contrast the sunflowers and their centers and to make minor changes with the leaves and vase. This still life is our graduation project.

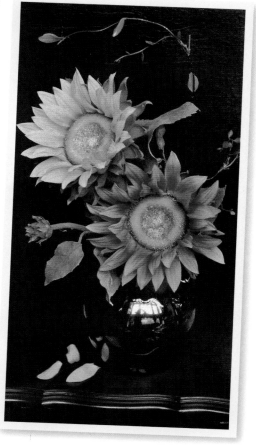

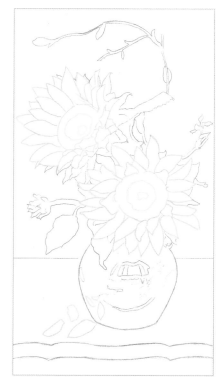

Step One I sketch the majority of the shapes with cool grey 70%. For the petals, I use yellow ochre with a sharp point and firm pressure.

Apple green	Black	Burnt ochre	Canary yellow	Chestnut	Chocolate	Cool grey 70%	Crimson red
Dark green	Dark umber	Kelly green	Kelp green	Light umber	Mineral orange	Moss green	Olive green
Pumpkin orange	Sienna brown	Terra cotta	Tuscan red	White	Yellow ochre	Yellowed orange	

58

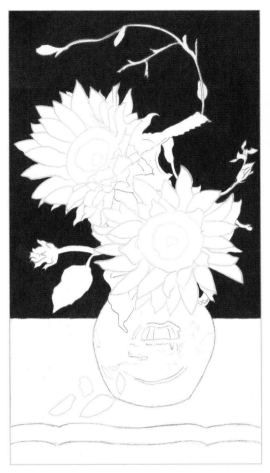

Step Two The background is quite dominant in this piece. To create it, I use medium pressure to lay down black, then dark green, and then black again. I use tight circular strokes with firm pressure for the final coat of black.

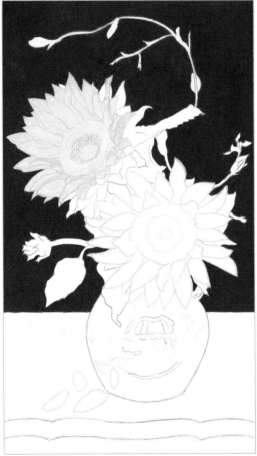

Step Three I add a wash of canary yellow over the top sunflower and redraw missed petals with my yellow ochre pencil. I add a light coat of Kelly green over the center.

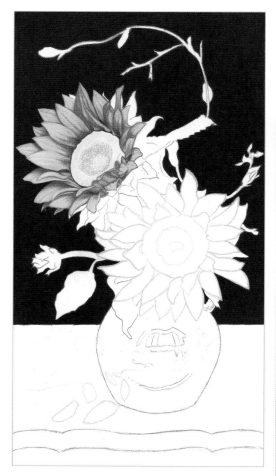

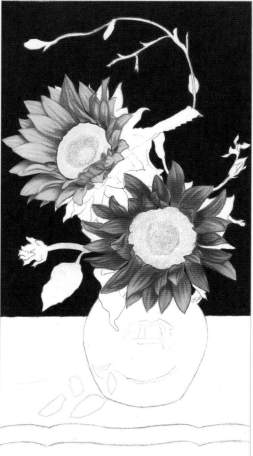

Step Four I place a light coat of yellowed orange over each petal and brighten with a firm application of canary yellow. For the streaks, I use light umber with an overcoat of mineral orange. Then I blend down with canary yellow. I use terra cotta in the reddish areas and burnt ochre on the petal edges. At the base of the petals and in the shadows, I apply chocolate and dark umber. I use Tuscan red sparingly to enhance the reds and yellow ochre to mute any overly bright yellows.

Step Five I begin the second sunflower with a light wash of canary yellow to establish my brightest yellow highlights. I follow with an application of pumpkin orange everywhere except atop the highlights. Then I blend terra cotta and crimson red over the pumpkin orange. I create the streaks in the petals with Tuscan red and finish with yellowed orange. Wherever I need deep shadows or a darker hue, I use dark umber. Black fills in the crevices between some of the petals. Then I use yellow ochre and Kelly green to block in the center.

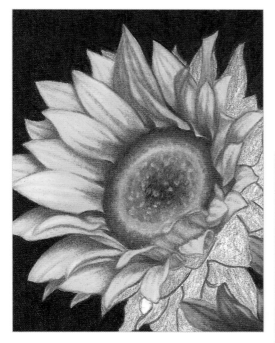

Step Six I add a layer of mineral orange and then canary yellow in the center of the yellow sunflower. I rim much of the yellow circle with terra cotta and then use heavy pressure to add dark umber outside of that. In the innermost green circle, I start with a coat of Kelly green and finish with dark green and a bit of dark umber for depth. I randomly place dots of pumpkin orange in the green center and swirl Kelly green around the dots. With a sharp point, I also apply dots of canary yellow.

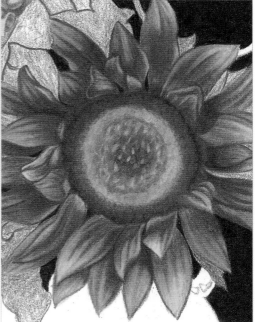

Step Seven I repeat Step Six to create the center of the red sunflower. Plus, I cover the outermost edge of the dark umber ring with a layer of black. Then I add a thin circle of Tuscan red between the black and terra cotta rims. The yellow looks too bright, so I swirl a coat of terra cotta over it using medium pressure. I also expand the dark green interior and use a final blend of Kelly green around the edges.

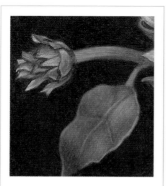

In Detail: I redraw the shape of the horizontal green stalk. I add a layer of kelp green and/or dark green with white on top. Then I use black and dark umber for the shadows and burnish with white in the lighter areas.

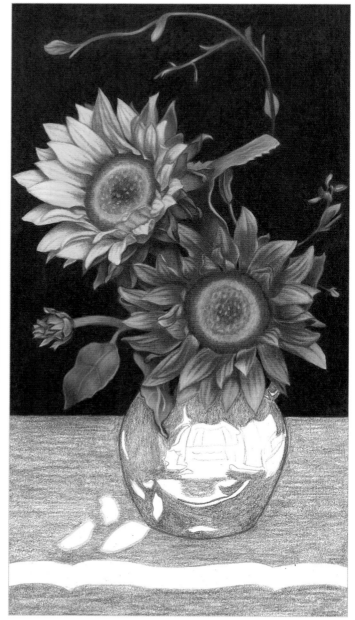

Step Eight I wash all of the greenery with dark green. For the leaves surrounding the flowers, I then layer kelp green. As needed, I lighten with white, darken with dark green, and use Kelly green to restore brightness. I use dark umber in the brownish shadows, black in the darkest ones, and yellow ochre in the small yellow areas. For the large leaf draped over the vase and the ones on the curved upper branch, I start with apple green and then white. I use dark green or olive green for the veins and color over the leaves with the same pencil or with moss green. Dark umber and white color the branches, and I clean up some of the leaf edges with black. Finally, I block in chestnut for the table and dark umber for most of the vase.

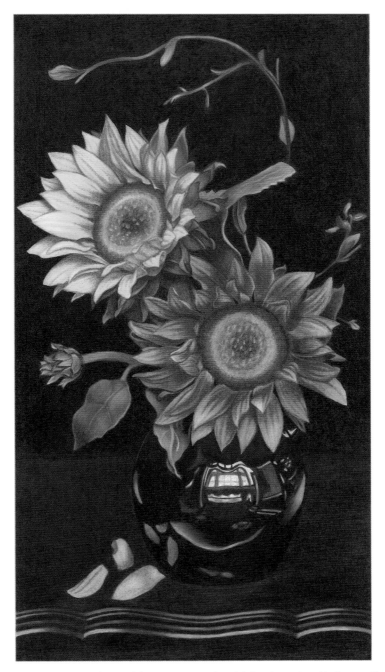

Step Nine Using medium pressure, I add coats of chestnut, Tuscan red, and dark umber to the table. I use small strokes and a sharp point to burnish with black. Then I apply crimson red on top and finish with more black in the darkest areas. For the horizontal table ledge, I use sienna brown, then dark umber, crimson red, and black for the very darkest stripes. I use light umber and white for the light stripes and dark umber for the shadows. White burnishes and smooths. I darken the vase with black and add the reflections of the room and window. I use cool grey 70% in the light areas and burnish with white. I lightly layer the brown areas with dark umber. I use yellowed orange for the light reflections on the right, the fallen petals, and the petal reflections. Next I layer dark umber over the reflected petals and add slight shadows and lines on the actual petals. A final finish of yellowed orange completes the petals. I erase all smudges and spray with fixative.

CLOSING THOUGHTS

Colored pencil is a fascinating yet manageable medium that can expand your artistic horizons. The low cost and visual impact have attracted many artists, and it is now enjoying acceptance with private collectors and fine art galleries internationally. My very first colored pencil project was an ambitious still life with an extremely busy background. However, my expectations were low, and I tackled it methodically by starting from the top and working my way to the bottom. It was certainly not my best piece, but I felt liberated from fears of failure and launched into this vibrant world of color with enthusiasm. I encourage you to look into other Walter Foster colored pencil books in addition to this one. Work through the exercises and then start snapping photos of your own. Sketch them onto paper and begin to create masterpieces that will improve with each project. You will be amazed and thrilled at what you can accomplish!